How to Draw Wild Animals

Step-by-Step Illustrations
Make Drawing Easy

An H.W. Doodles Drawing Book
by Heather Wallace

Written and illustrated by Heather R. Wallace. Copyright © 2014 by Heather R. Wallace. All rights reserved.

No part of this book may be reproduced or transmitted in any form or by any means whatsoever without written permission from the author and illustrator except in the case of brief quotations embodied in critical articles and reviews.

Every effort has been made to ensure that this book is complete and accurate. The publisher, author, and illustrator, however, are in no way responsible for any human error, typographical mistakes, or any consequences resulting from the use of this book.

ISBN-10: 1495289052

ISBN-13: 978-1495289057

Usage Information

These drawings are for personal use only and may not be resold. In addition, because these drawings are for personal use only, they may not be used to embellish any items that are intended for resale or for any commercial purposes whatsoever

Introduction

With the help of the easy-to-follow illustrations found in this book you'll quickly be able to learn how to draw a whole bunch of wild animals including a bear, a fox, a koala, a monkey, and many more. For each character, detailed step-by-step illustrations are provided so that you can easily follow along from start to finish.

The H.W. Doodles series of drawing books are ideal for beginning artists who would like to learn and improve their drawing skills as well as more advanced artists who are looking to practice and hone the skills that they have already acquired. So, with the help of this drawing book, absolutely anyone will be able to tap into their creative side.

These drawings can be completed on paper using drawing implements or, if you prefer to work digitally, then you can use your favorite drawing program instead. Either way, you're sure to have fun drawing all of the adorable wild animals found in this book.

Details on Different Drawing Methods

Depending upon the drawing method that you plan to use, there are a few things that you need to know before you begin.

Drawing on Paper

When working on paper, use a pencil to very lightly sketch each step. After you have finished sketching the drawing, use a permanent marker to trace the pencil lines that you want to keep. After the ink has dried, use your eraser to remove any pencil lines that are no longer needed. Then, if you wish, color in your drawing using your preferred method.

Drawing Digitally

When drawing digitally, you will need to use the various tools (pen, pencil, shapes, layers, etc.) that are available in your program to create these drawings. After the

drawing is complete, you can either color the image on your computer or, if you prefer, print the drawing and then color it on paper using your preferred method.

An Important Note About Erasing

Sometimes, when creating these illustrations, you'll notice that you need to draw over something that you previously drew and the lines underneath have disappeared. When that happens, just erase the lines that are no longer shown in the illustration because they won't be needed to create the final drawing.

Drawing Supplies

The number of tools available to artists may seem daunting, but the good news is that you only need a few basic items to complete these drawings. However, the type of tools you need will depend on whether you plan to complete these drawings on paper or if you will be drawing digitally.

Supplies for Drawing on Paper

First, let's look at what you'll need to complete this lesson when drawing on paper.

Pencil

Pencils vary from very soft to hard and each is suited to a particular use. For the purposes of this book, however, a standard writing pencil, labeled #2/HB, will do nicely.

Marker

The drawings in this book have an inked-appearance. This can be achieved by using permanent markers to trace your pencil lines after you have finished sketching.

Eraser

An eraser is great for correcting mistakes and, also, for removing sketch marks after

your drawing has been inked. A vinyl eraser is recommended. This type of eraser is non-abrasive, which means that it will not damage your paper. It is also well-suited to erasing light marks and for precision erasing, so you should find that it works nicely.

Paper

As you learn, an inexpensive sketch pad will be sufficient. However, once you have mastered these drawings, you might want to create them again using drawing paper of a higher quality. That way you will be able to preserve copies of your drawings that are of a more professional quality.

Miscellaneous Supplies

In addition to the aforementioned, there are a few more items that you should add to your artist's toolkit. First, a pencil sharpener will be required to keep your pencil from becoming dull. Also, while not absolutely necessary, you might find that a compass and a ruler come in handy when attempting to draw certain shapes.

Supplies for Drawing Digitally

If you are planning to draw digitally, then there are really only three things that you need to complete these drawings. First, you need a computer. Secondly, you need a drawing program. Lastly, you need some sort of input device to draw with. Depending upon your preferences, this can be either a mouse or a drawing tablet.

Practice Makes Perfect

Don't be discouraged if your drawings doesn't look quite right after your first attempt. The great thing about drawing is that the more you practice, the better you become, which means that with each attempt you will become more skilled as an artist. So, just keep practicing and, before you know it, you will be able to draw a bunch of wild animals perfectly.

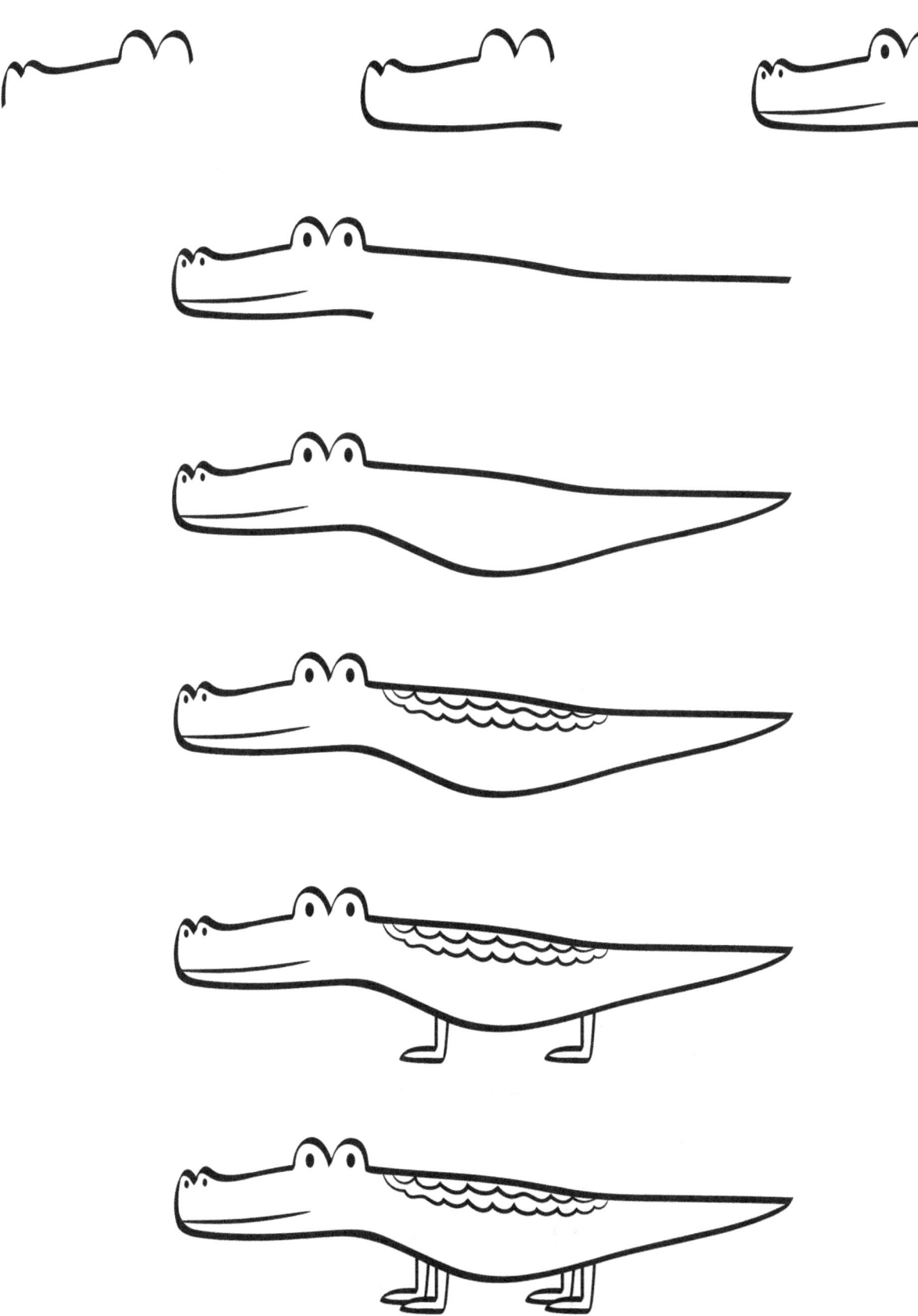

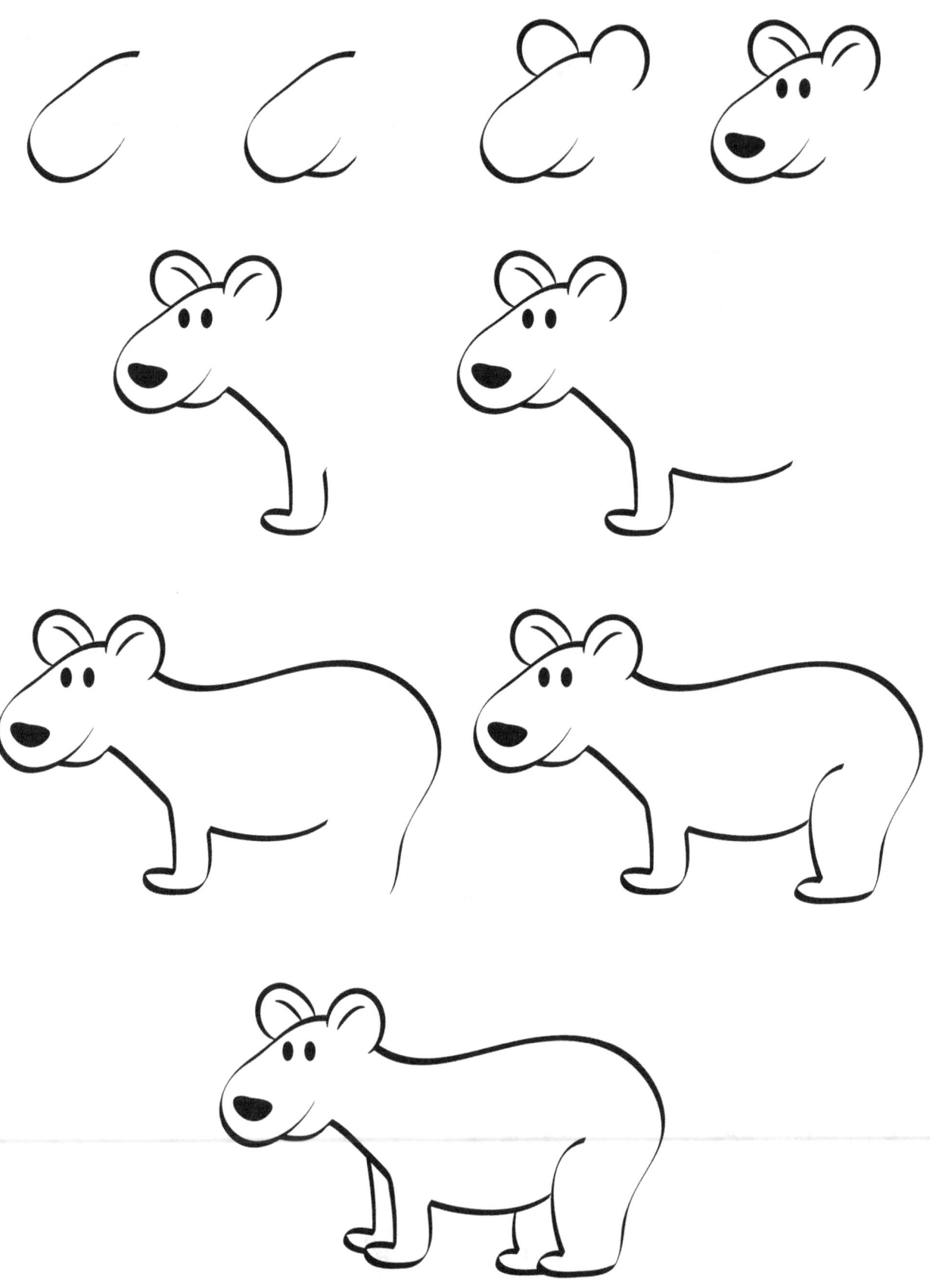

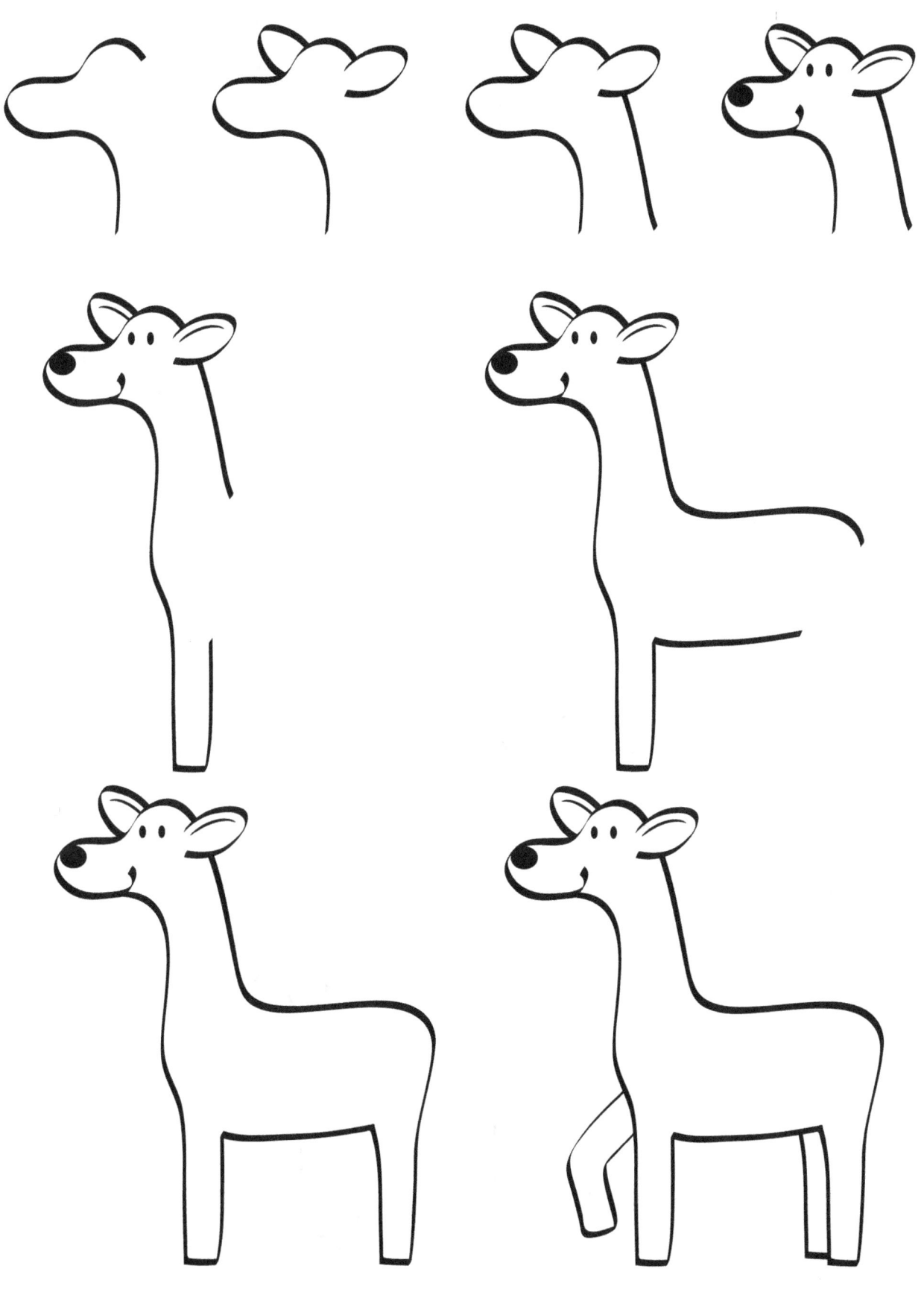

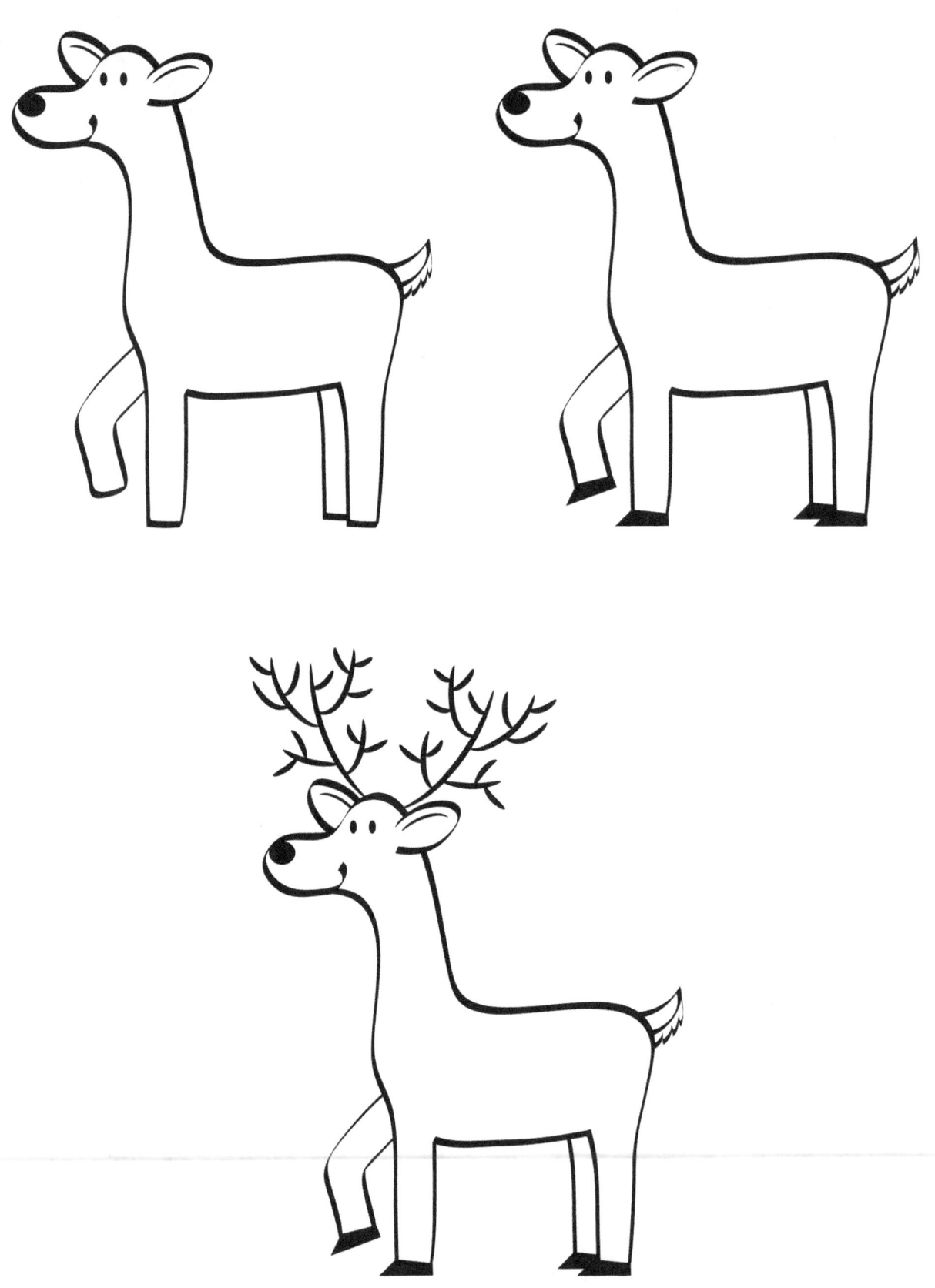

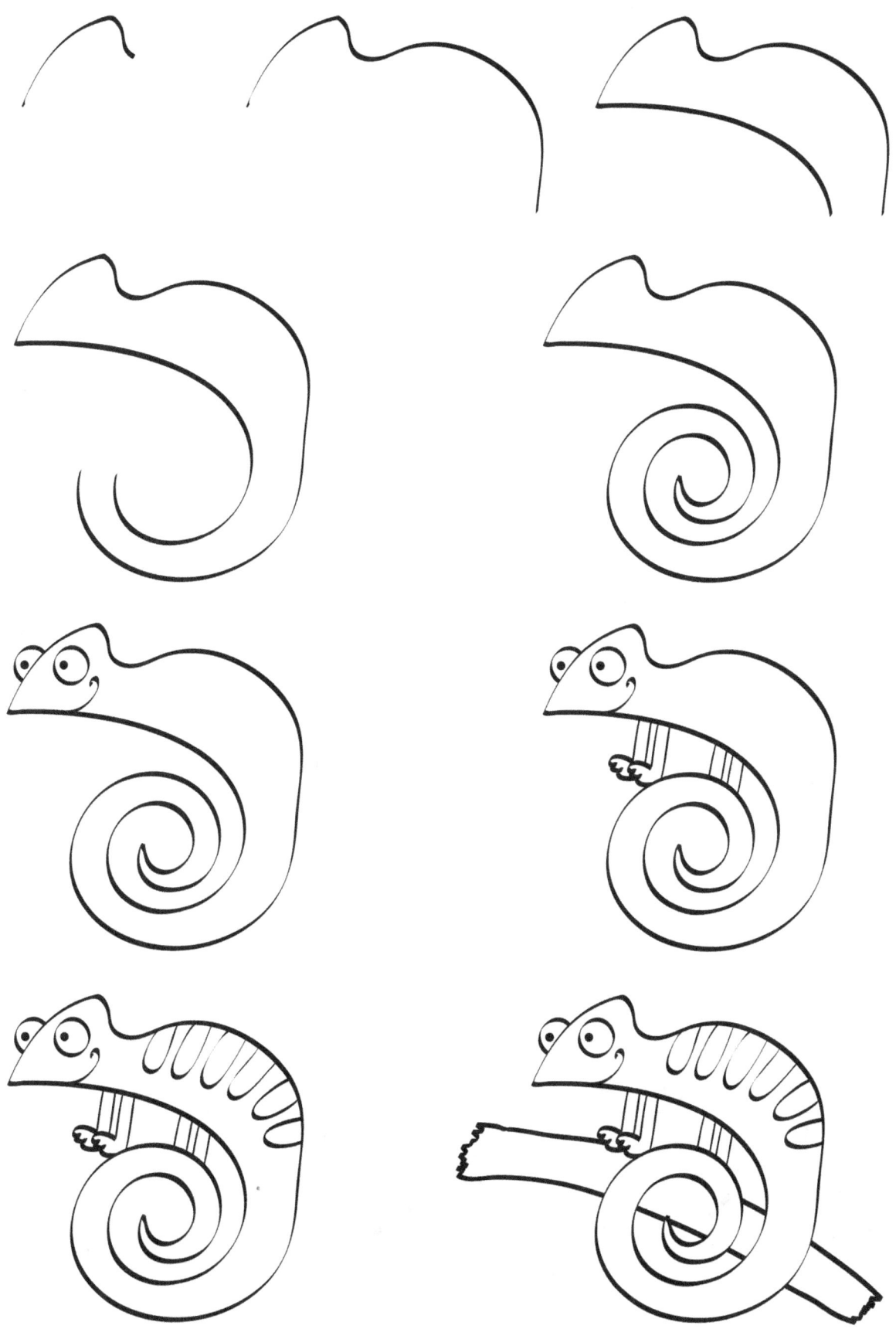

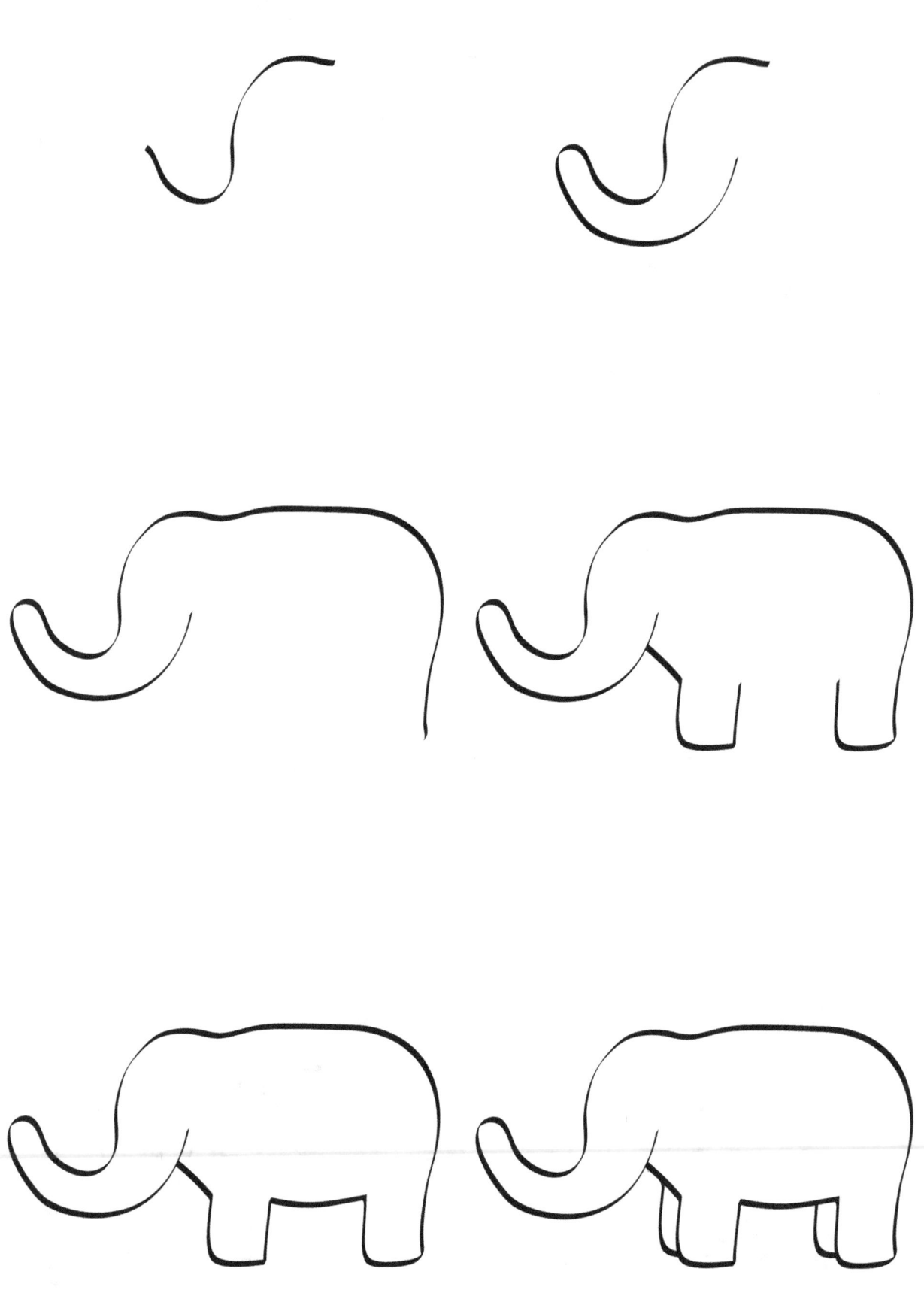

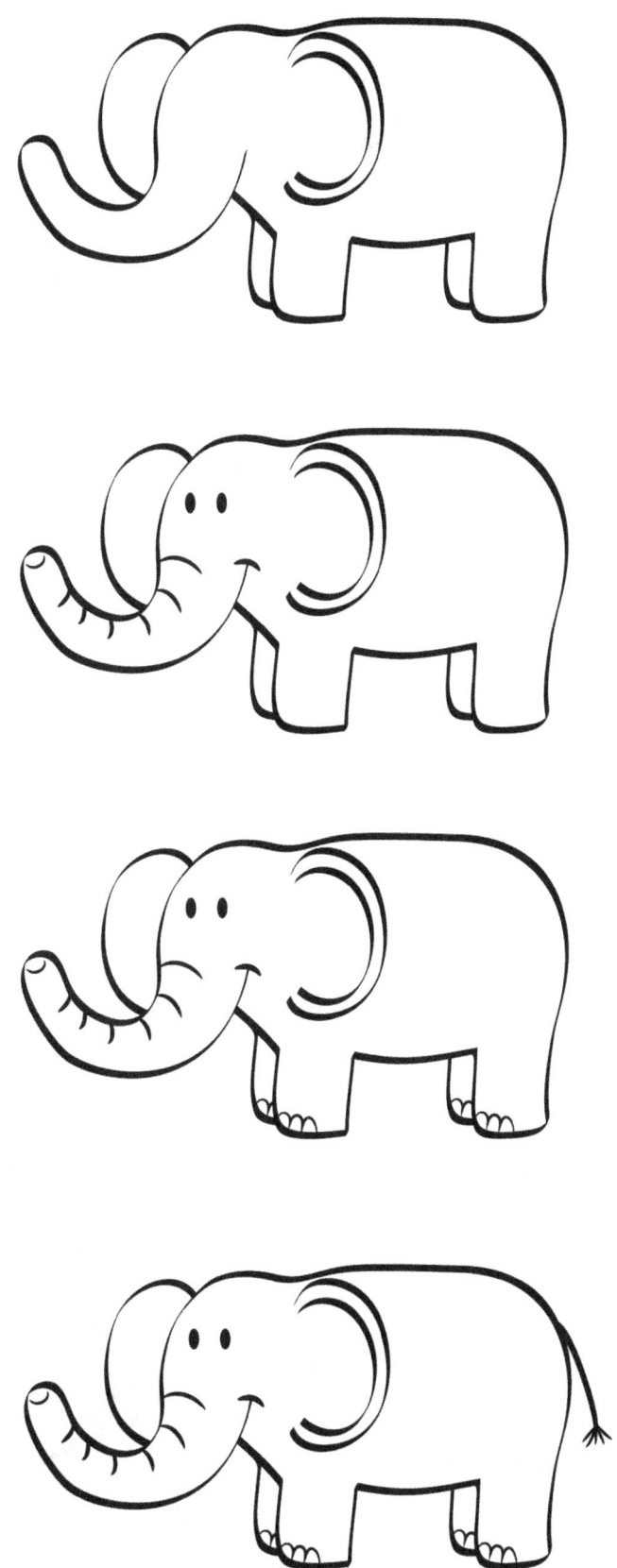

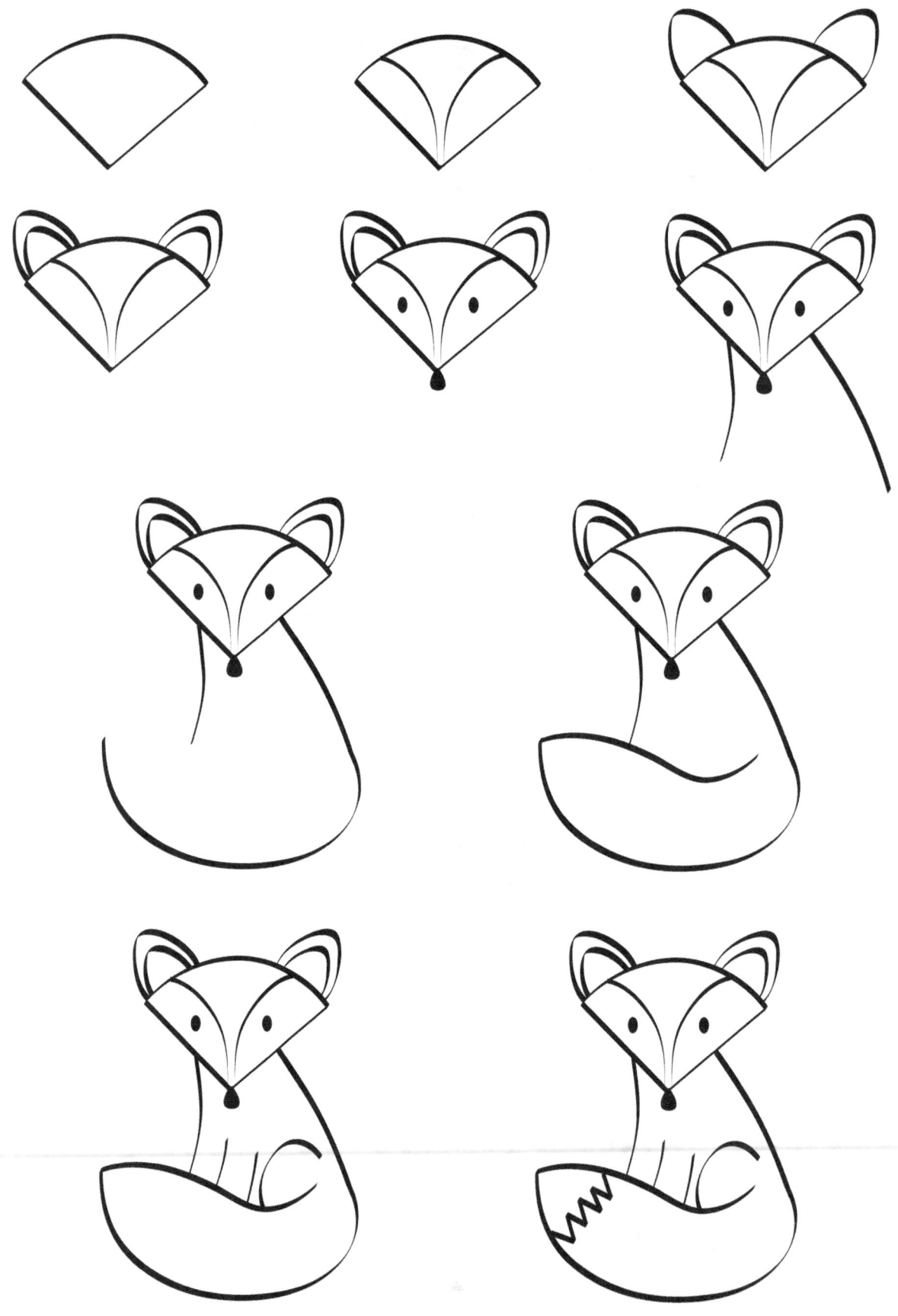

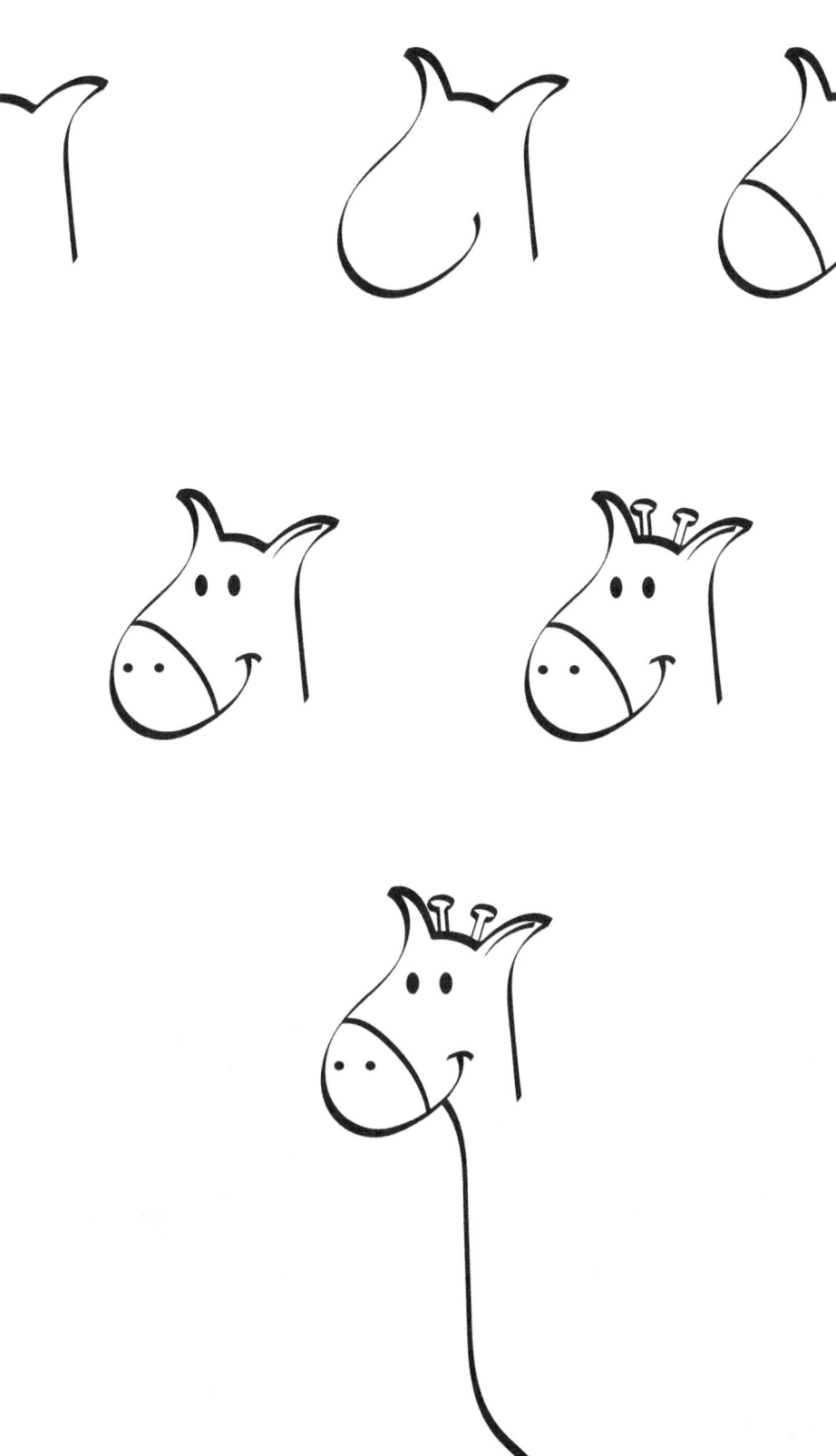

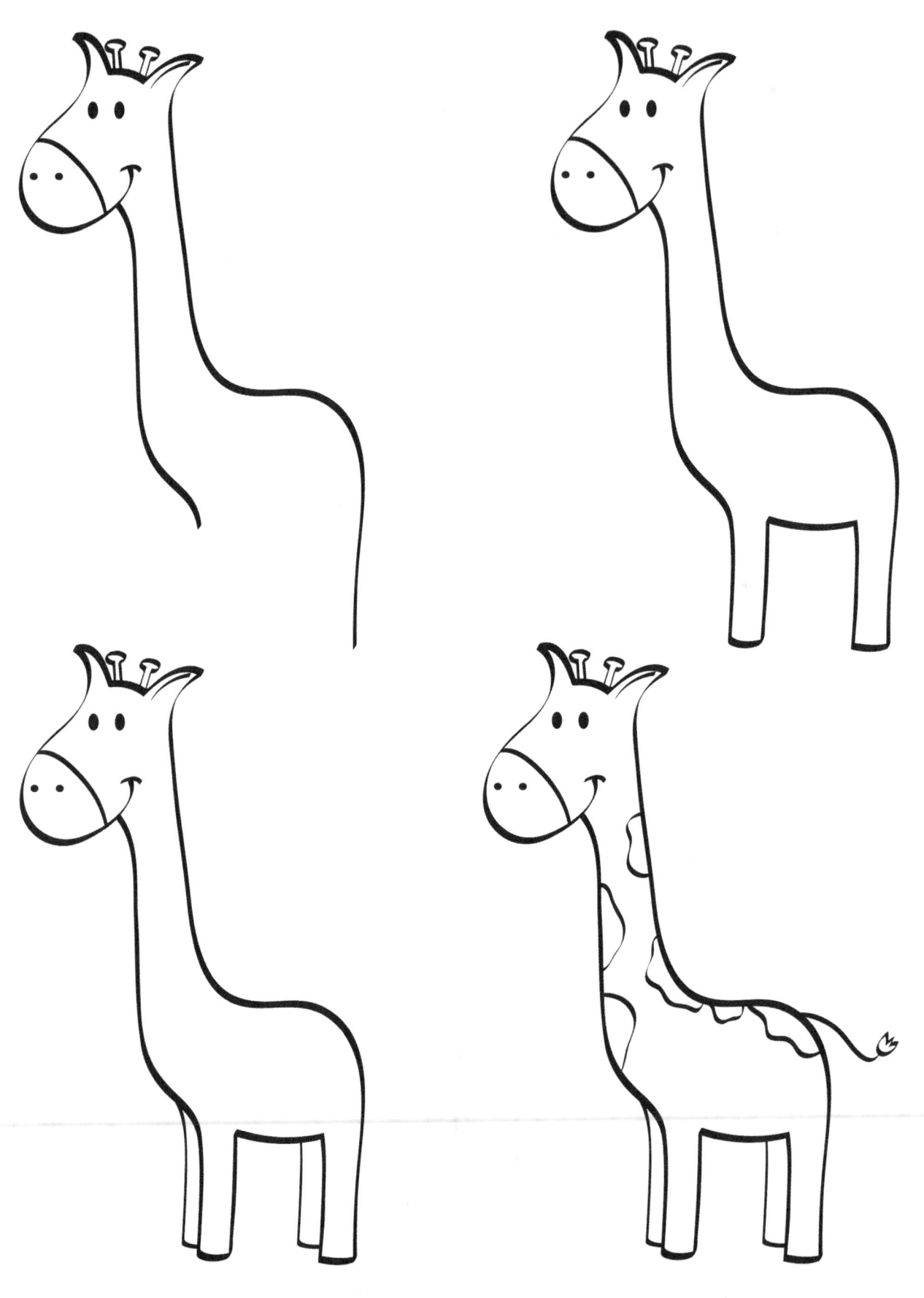

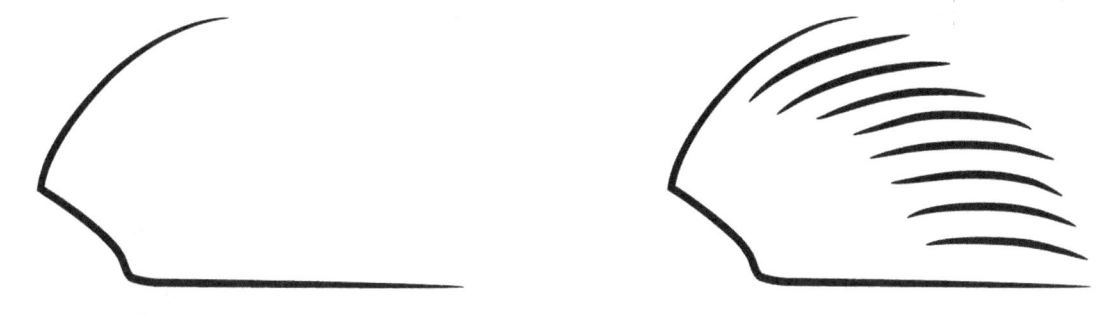
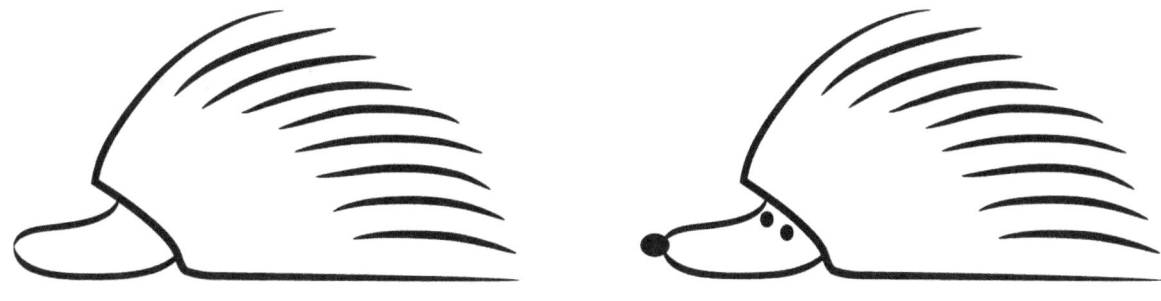
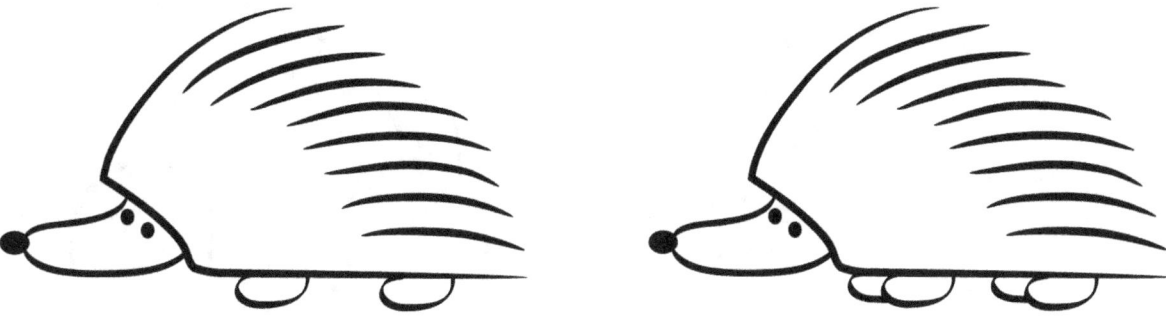

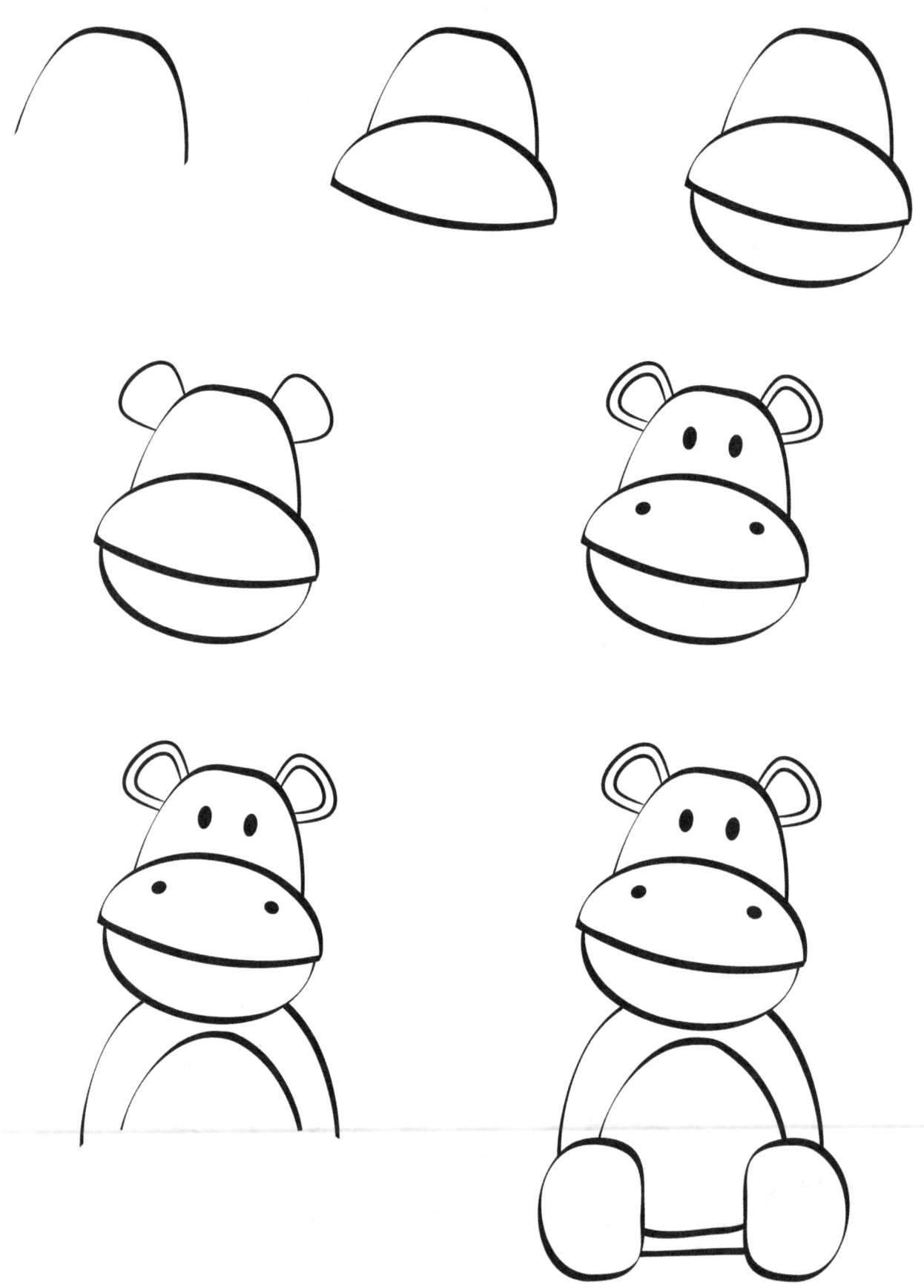

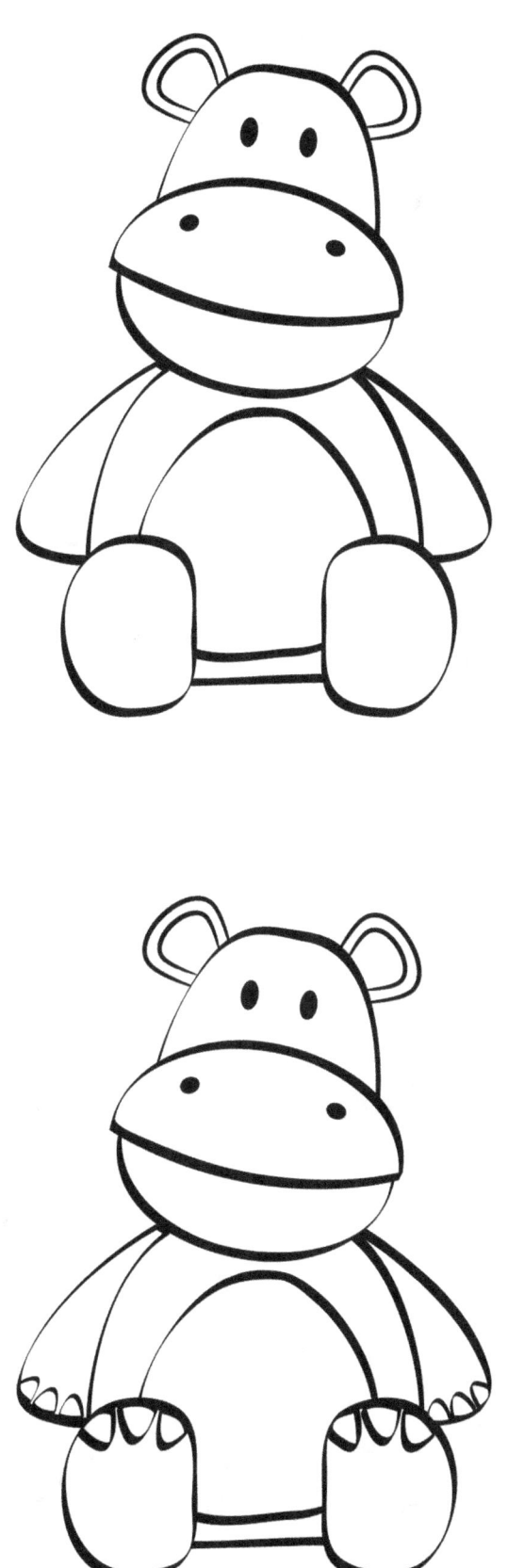

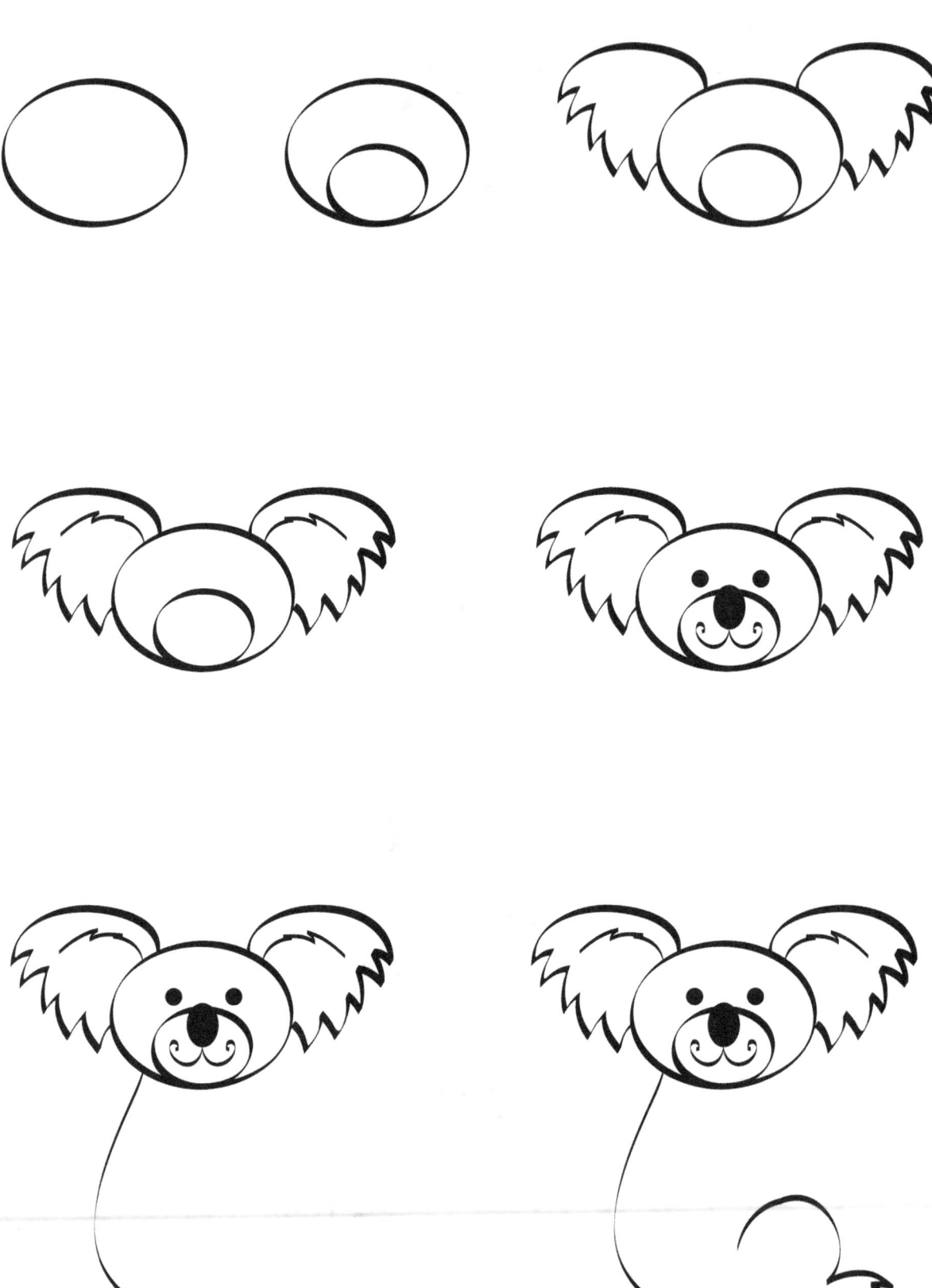

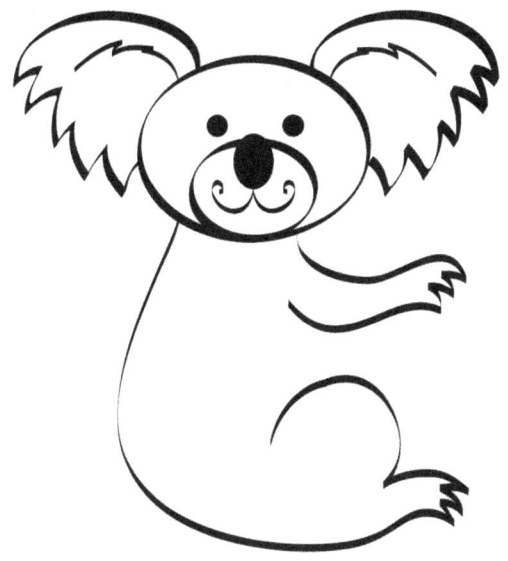

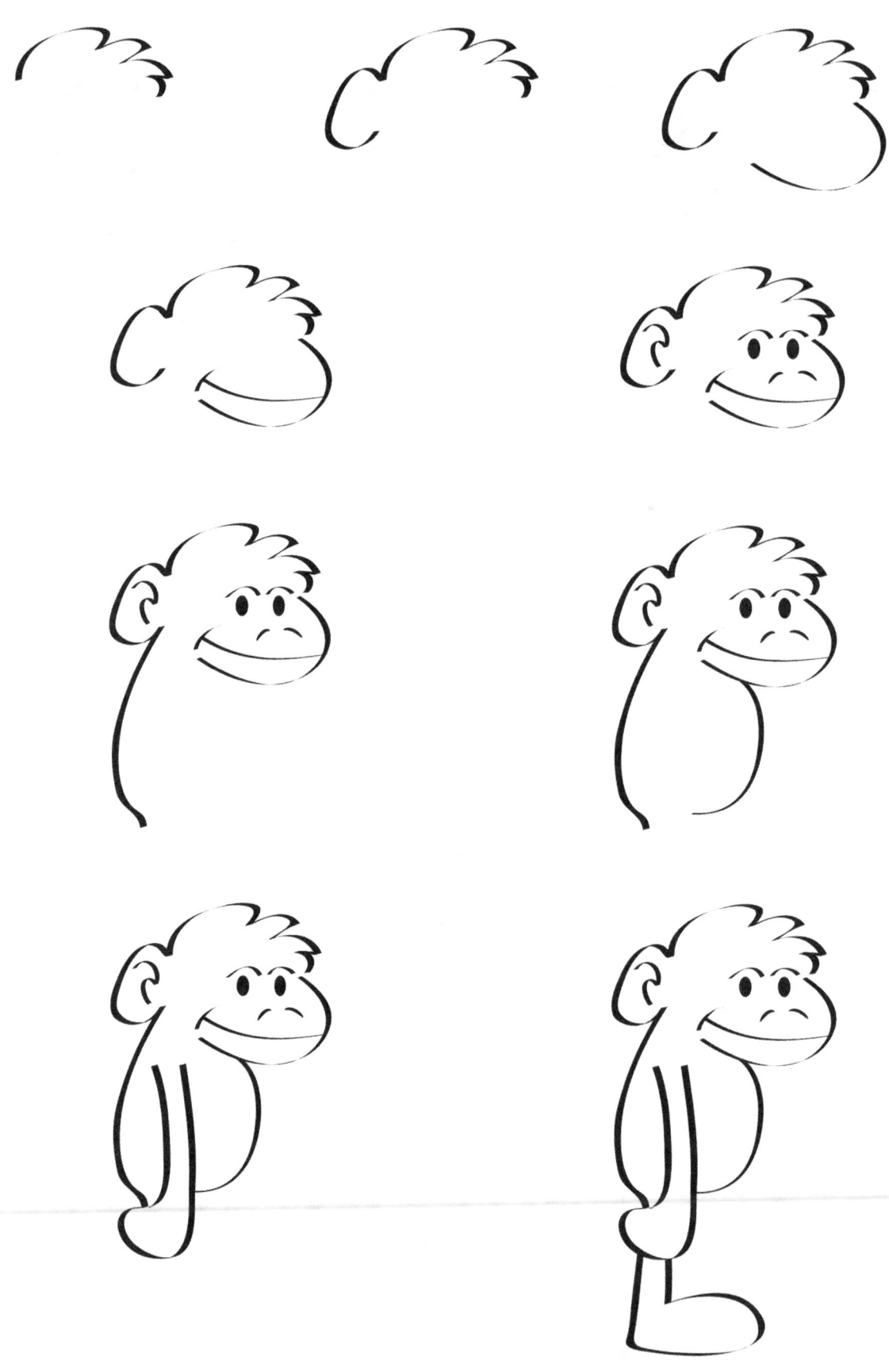

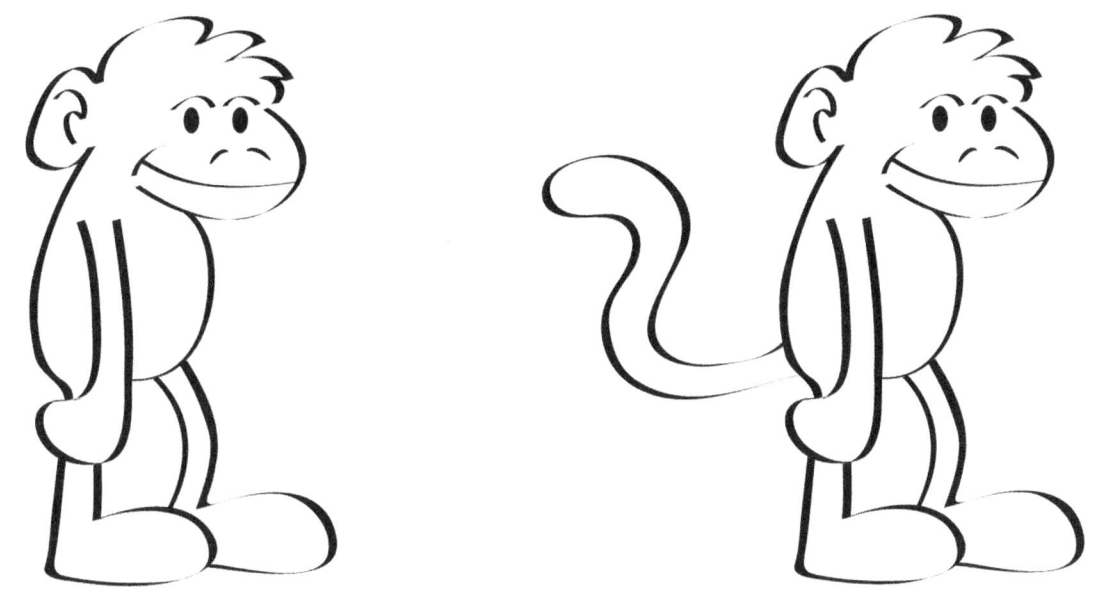
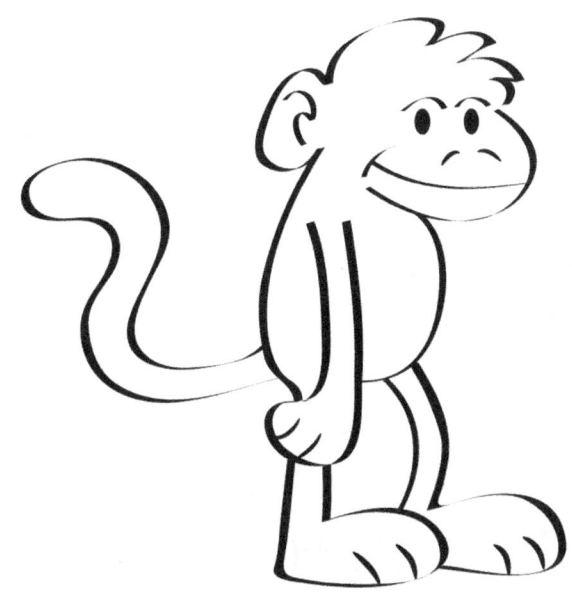

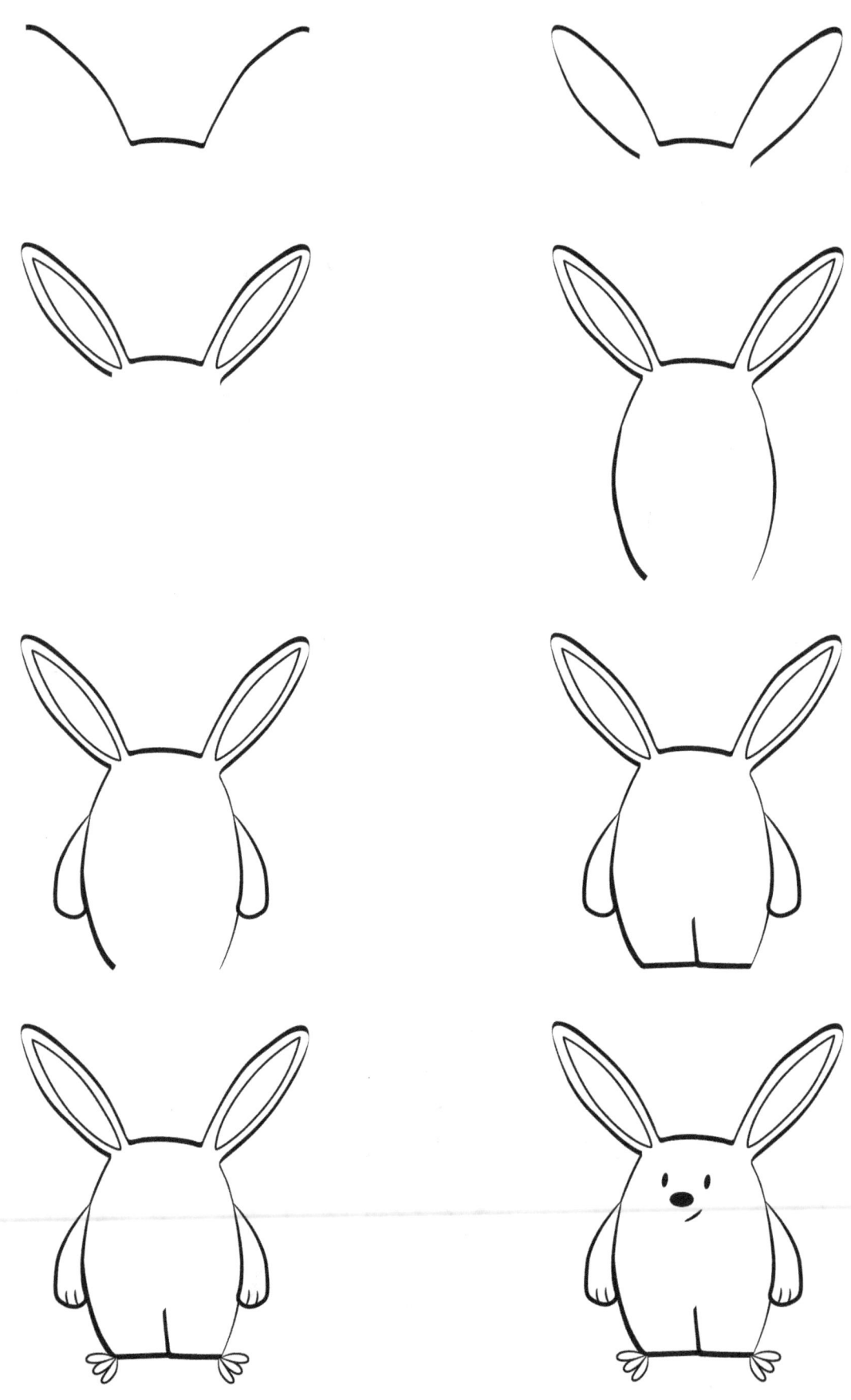

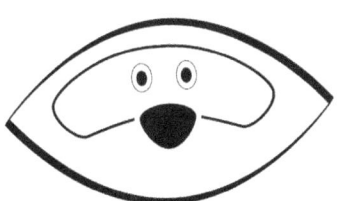 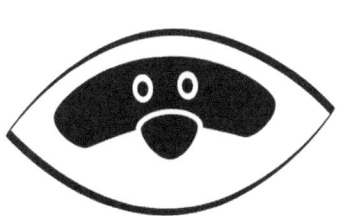 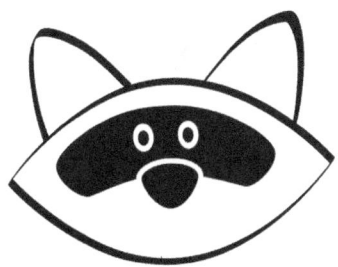
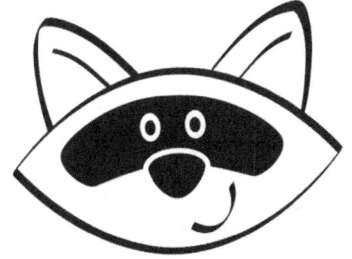 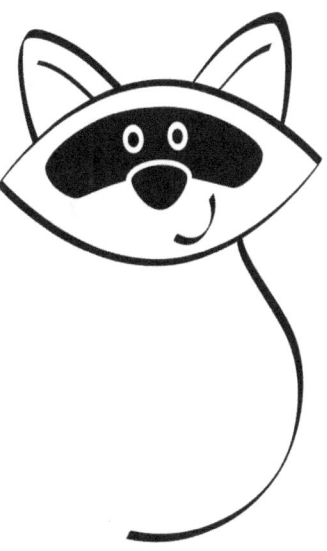

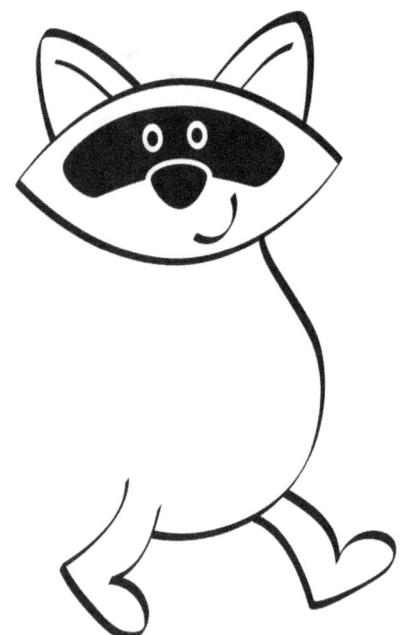
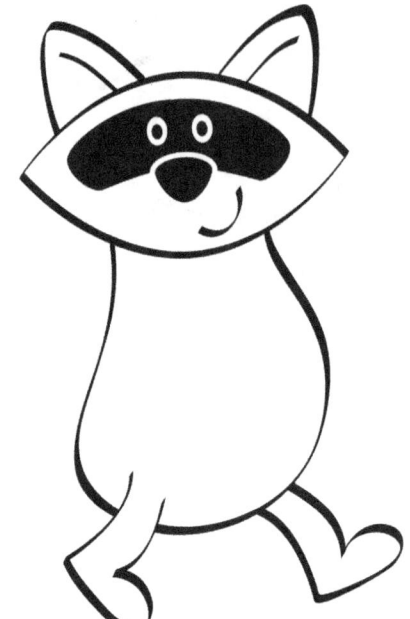
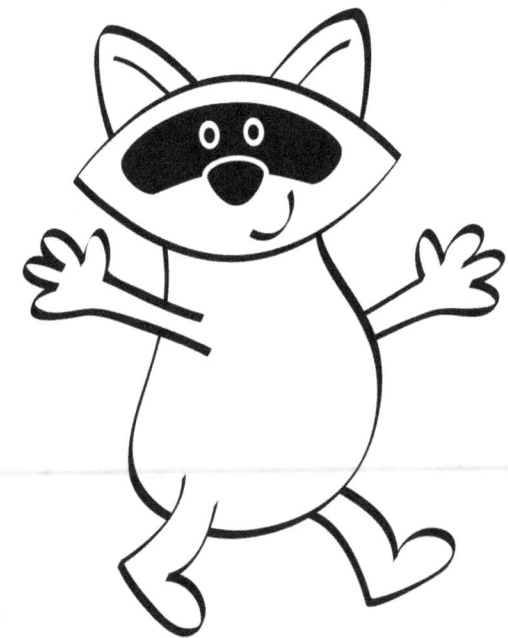

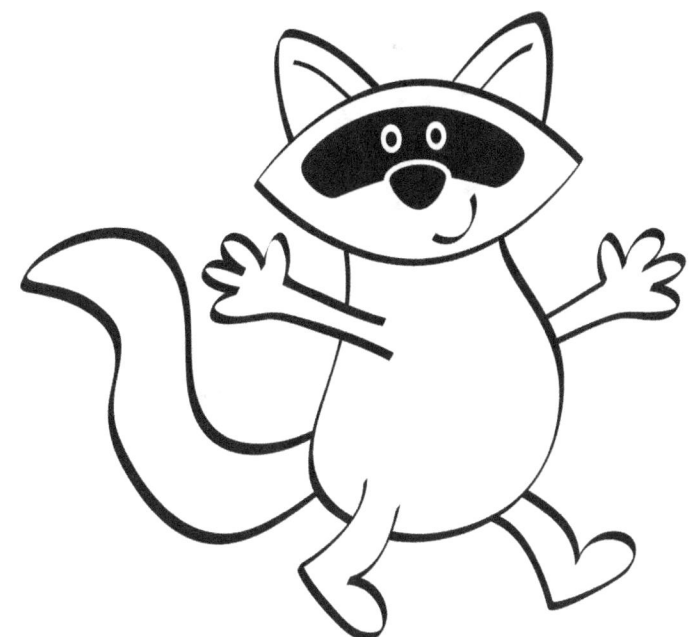
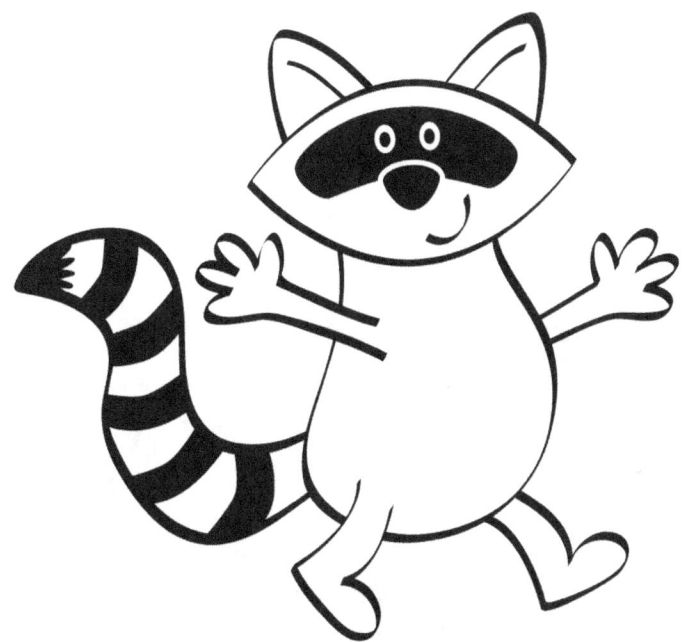

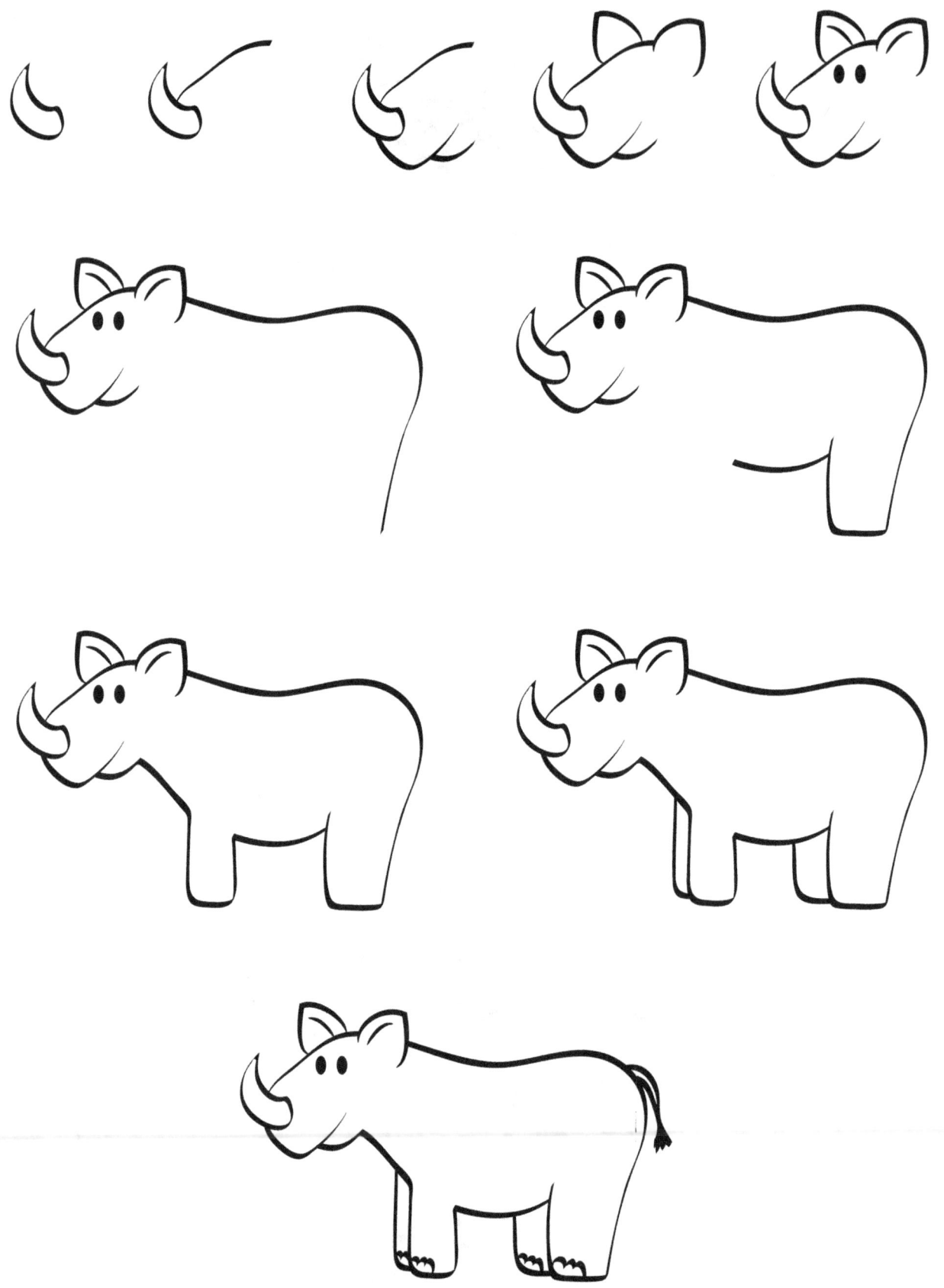

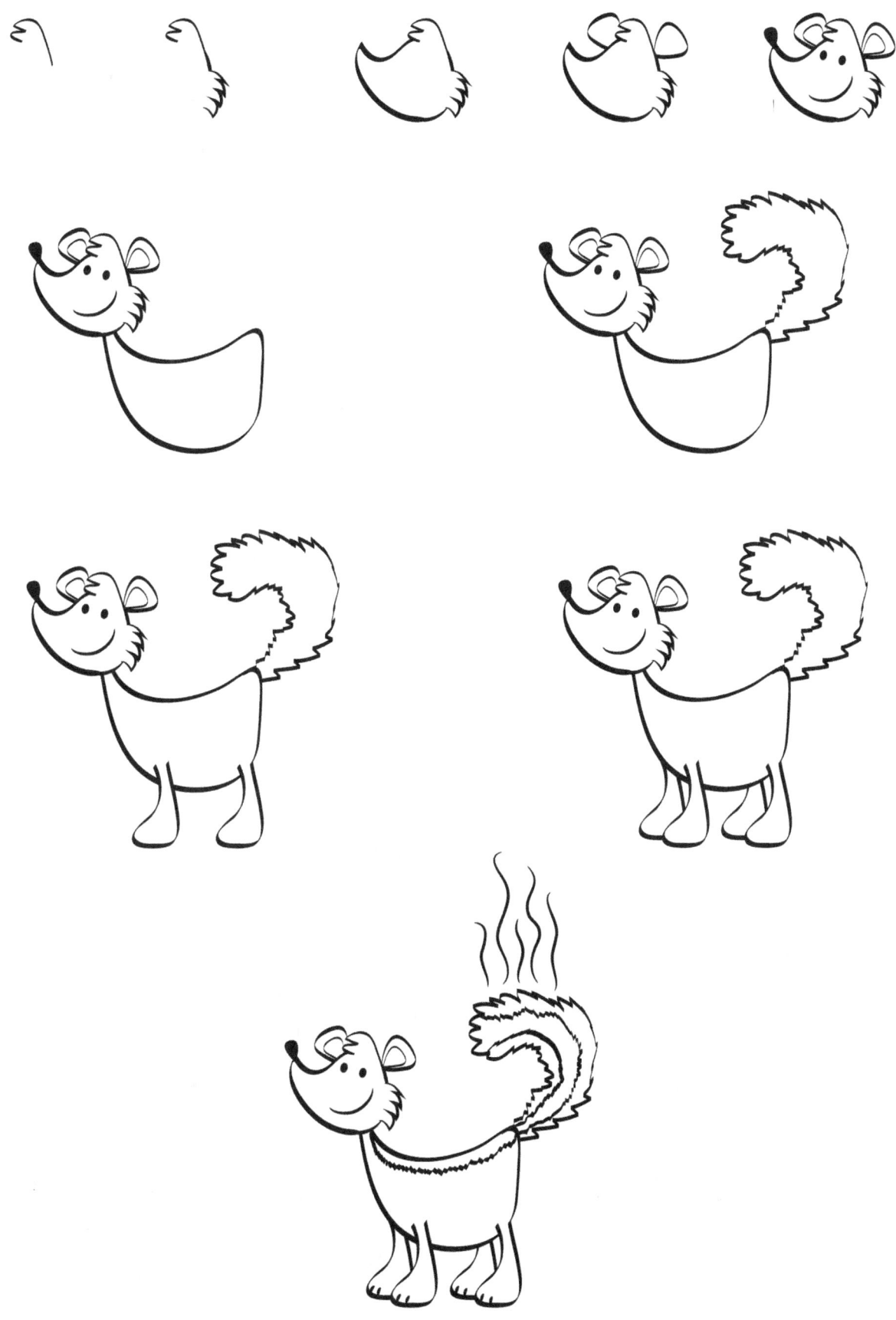

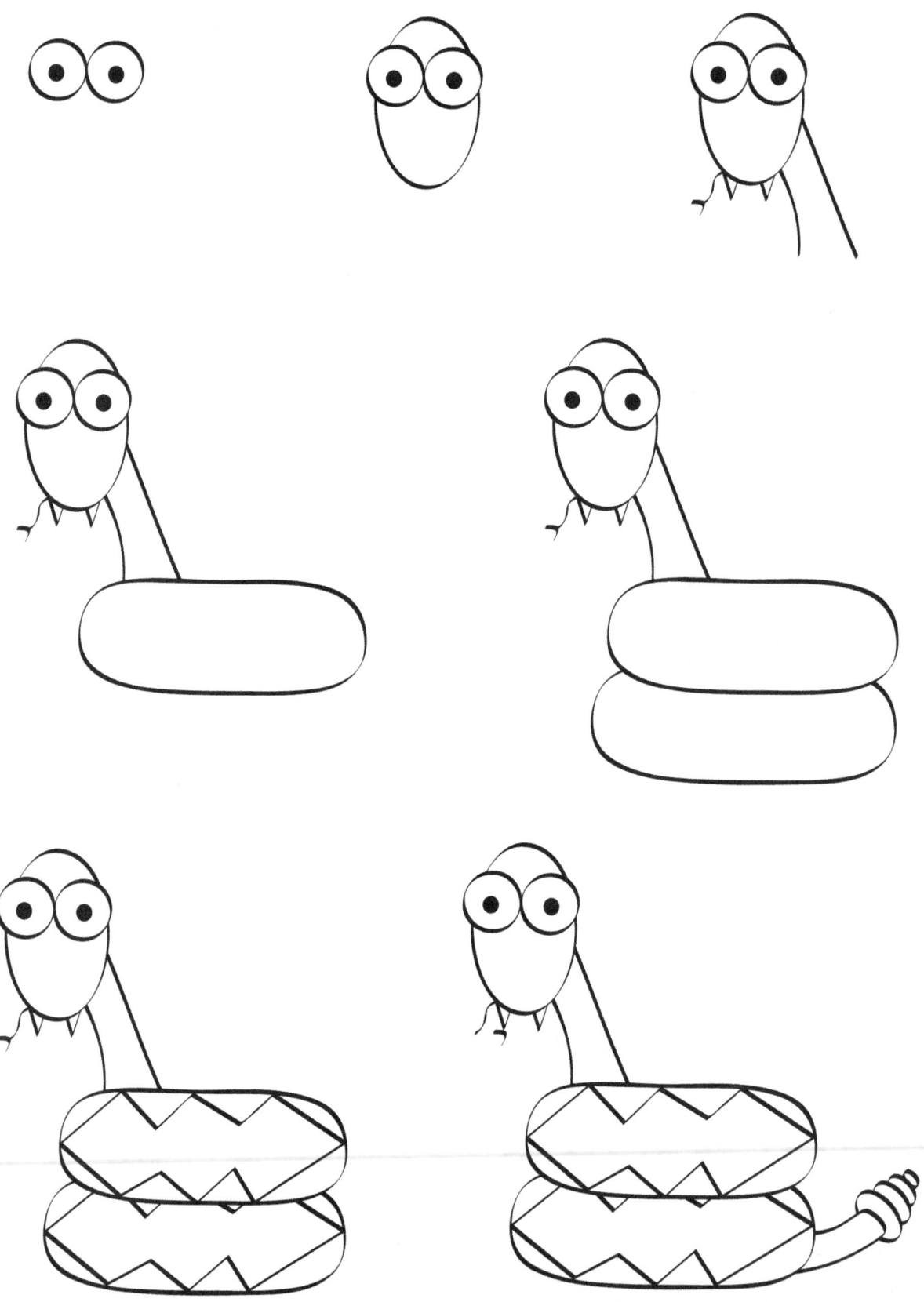

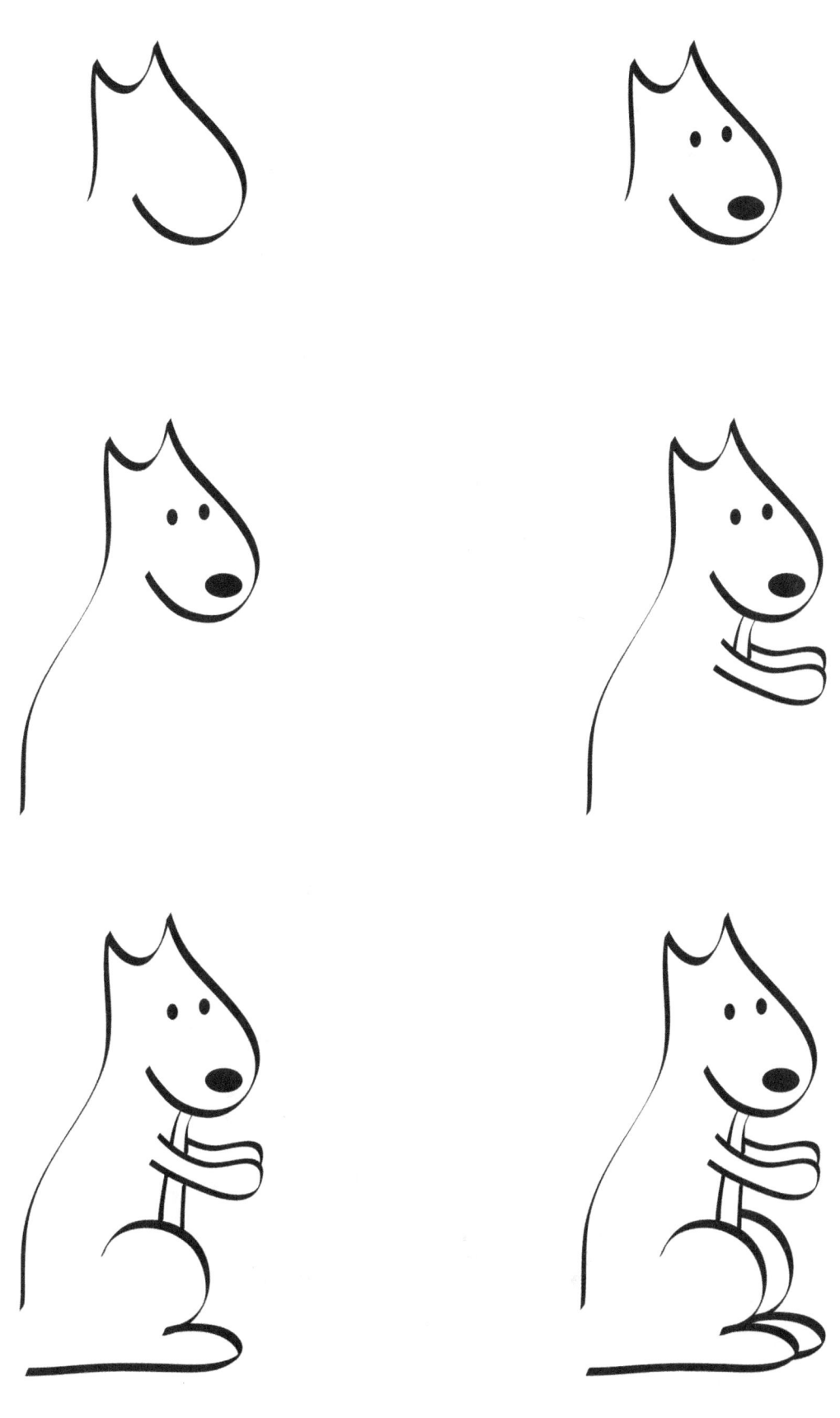

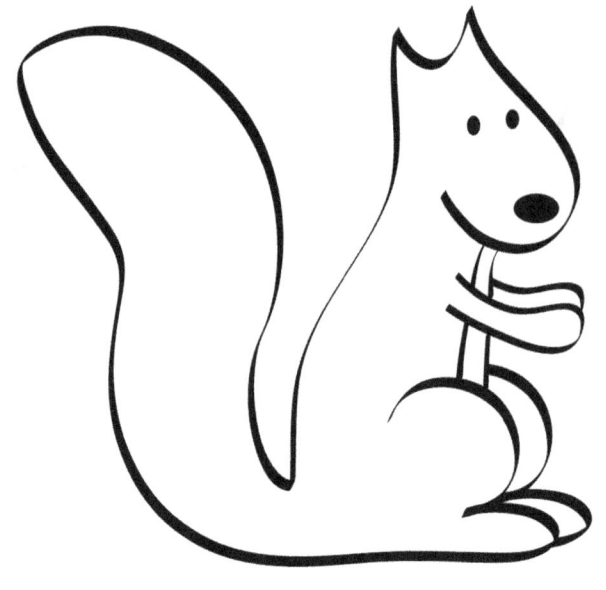
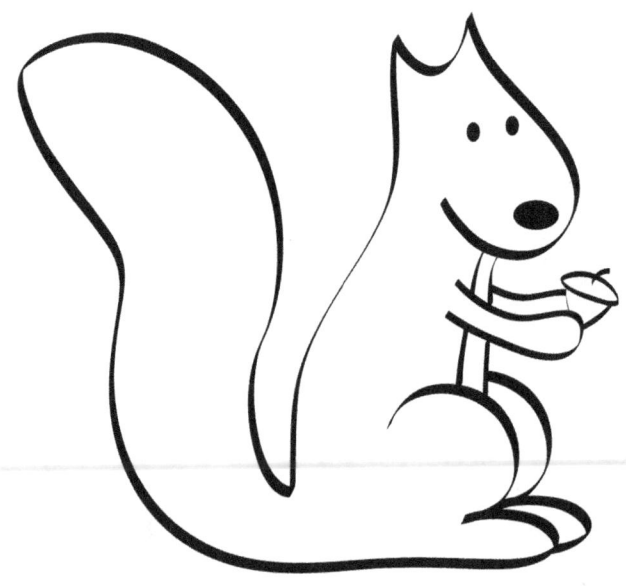

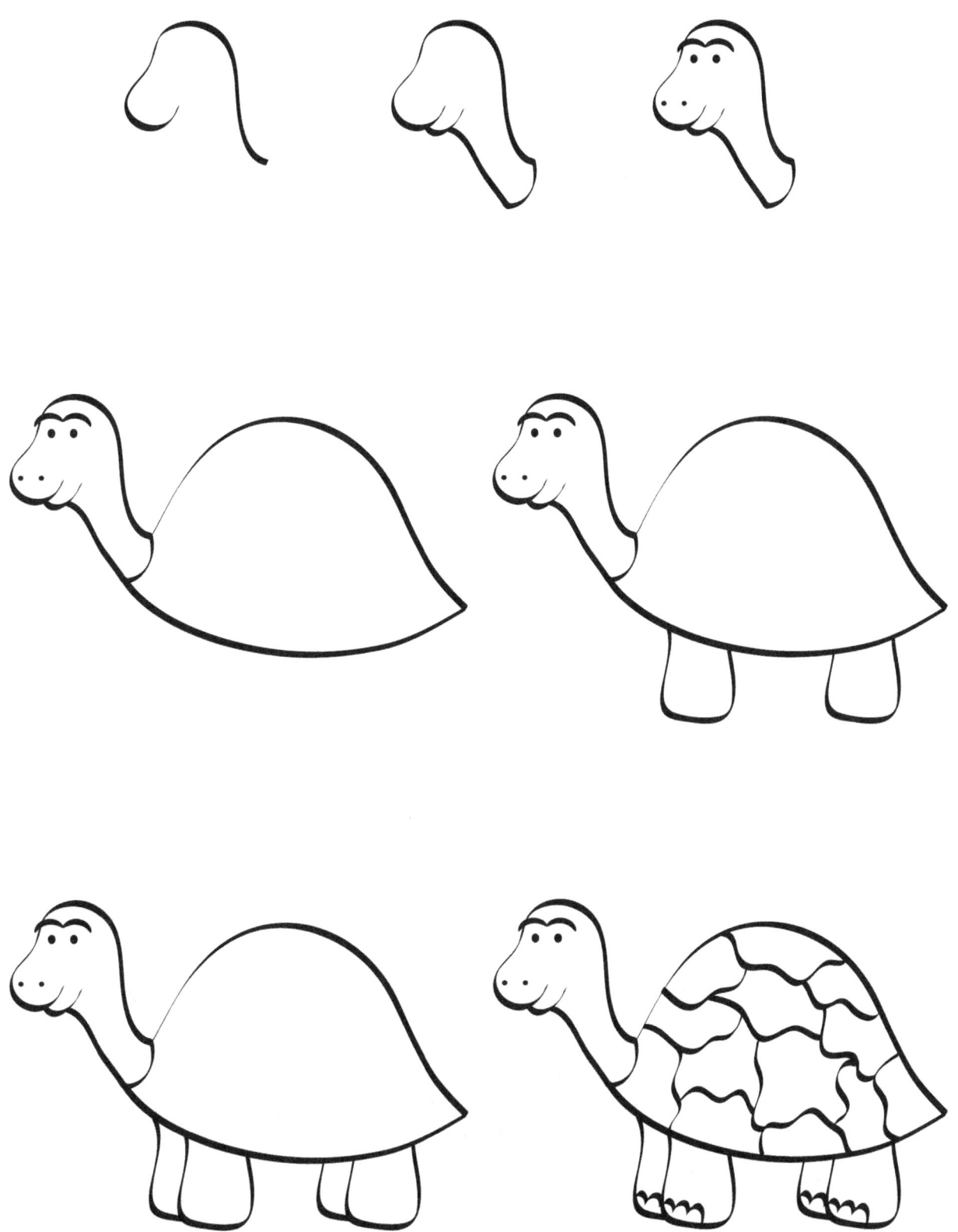

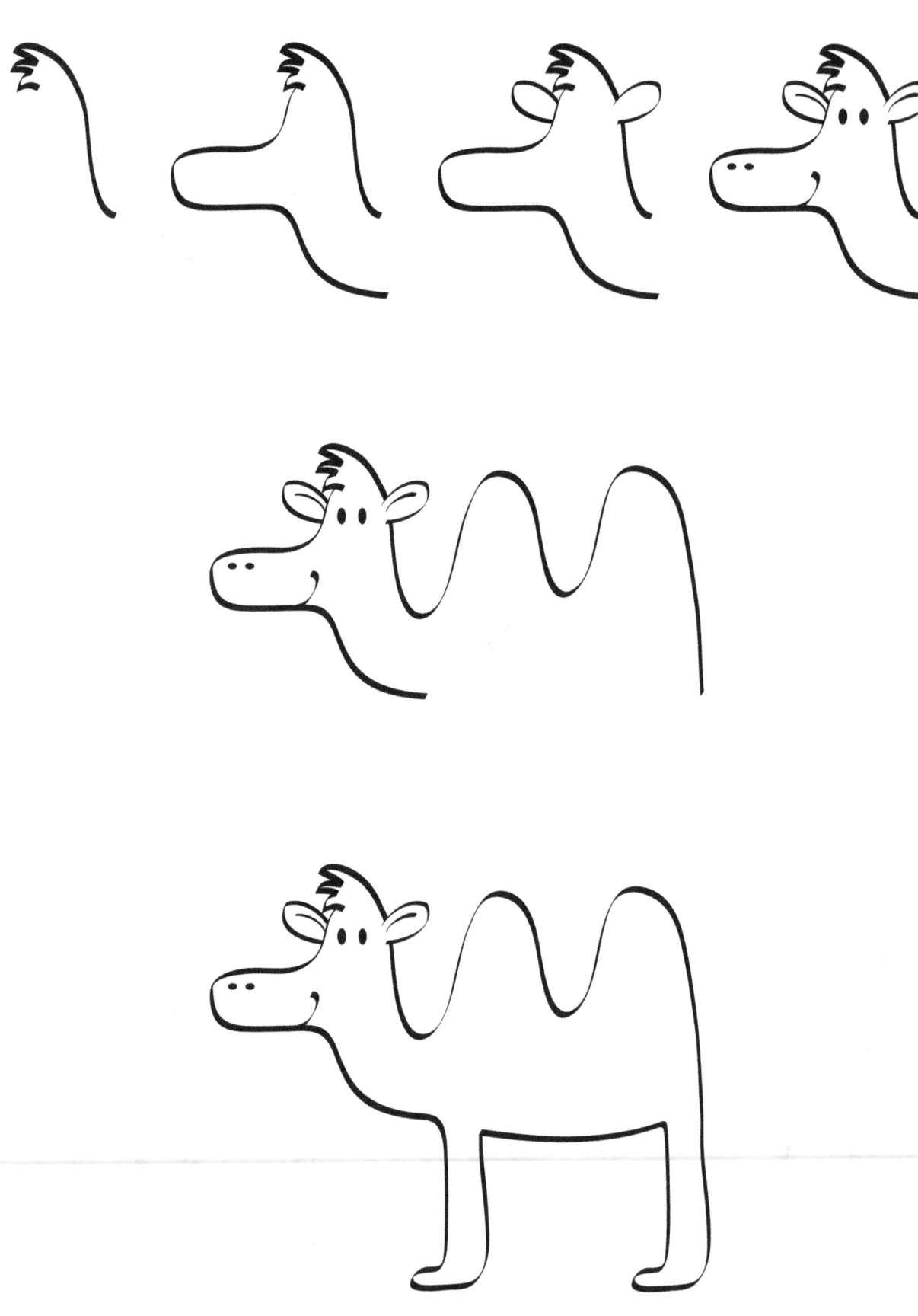

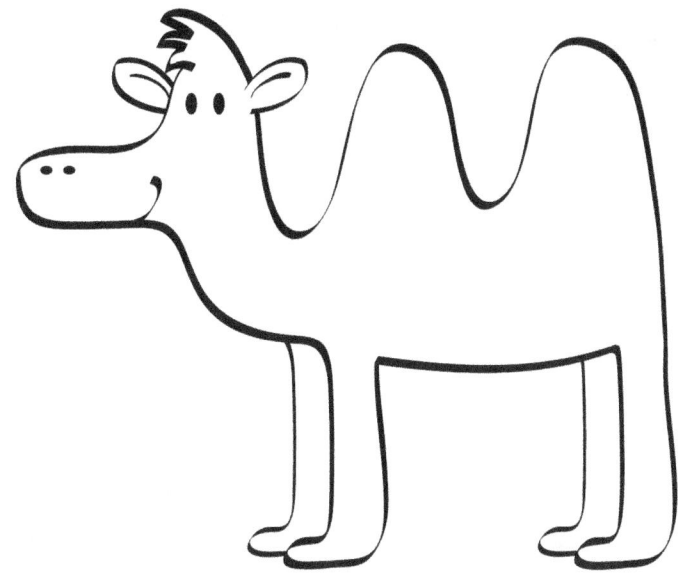
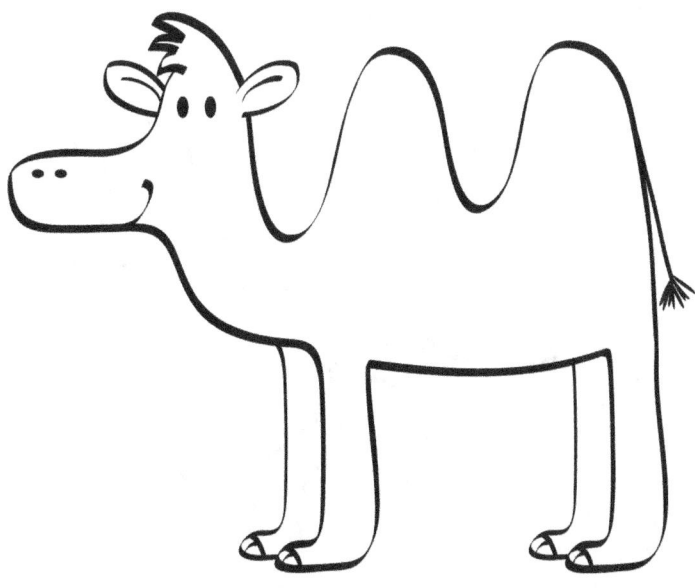

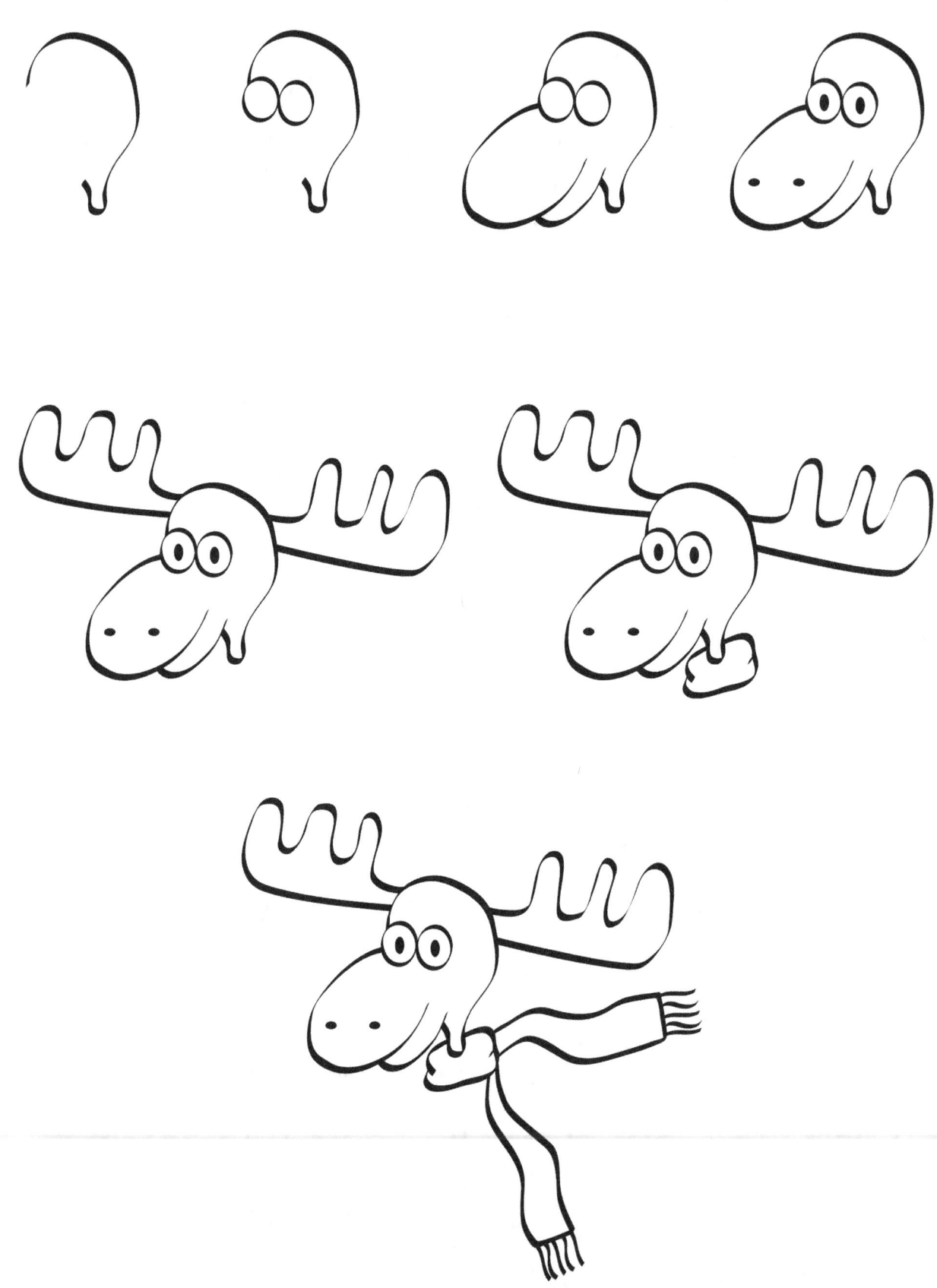

Thank you for buying *How to Draw Wild Animals*!

Word-of-mouth is crucial to the success of any book. So, if you enjoyed *How to Draw Wild Animals*, please help others discover it by taking a few minutes to do one of the following. Anything you do will be greatly appreciated. Thanks again for buying the book and, also, for helping to spread the word.

- write a review at Amazon
- recommended it to a friend
- buy a few copies to give as gifts
- share it with the readers of your blog (if you have one, of course)
- add it to a Listmania! list or a So You'd Like To... guide at Amazon
- send a Tweet about the book
- add it to your Shelfari, LibraryThing, and/or Goodreads book collection

H.W. Doodles Drawing Book Series

How to Draw Cats and Kittens

How to Draw Dogs and Puppies

How to Draw Monsters

How to Draw Wild Animals

How to Draw Halloween Pictures

www.ingramcontent.com/pod-product-compliance
Lightning Source LLC
Chambersburg PA
CBHW081806170526
45167CB00008B/3347